FIELDS OF VISION

The Photographs of Russell Lee

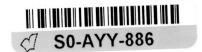
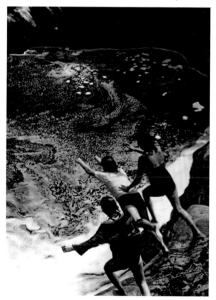

FIELDS OF VISION

The Photographs of Russell Lee

Introduction by Nicholas Lemann

THE LIBRARY OF CONGRESS, WASHINGTON, D.C.

g

For The Library of Congress:
Director of Publishing: W. Ralph Eubanks
Series Editor and Project Manager: Amy Pastan
Editors: Aimee Hess and Wilson McBee

For D. Giles Limited:
Copyedited and proofread by Melissa Larner
Designed by Miscano, London
Produced by GILES, an imprint of D. Giles Limited,
London
Printed and bound in China

**The Library of Congress is grateful for the support of
Furthermore: a program of the J.M. Kaplan Fund**

The Library of Congress, Washington, D.C., in
association with GILES, an imprint of D. Giles Limited,
London

Library of Congress Cataloging-in-Publication Data
Lee, Russell, 1903–
The photographs of Russell Lee / introduction by
Nicholas Lemann.
p. cm. -- (Fields of vision)
ISBN 978-1-904382-39-3 (alk. paper)
1. Documentary photography--United States.
2. United States--Social life and customs--1918-1945--
 Pictorial works.
3. Lee, Russell, 1903– I. Title.
TR820.5.L41956 2008
779.092--dc22
2007042283

Frontispiece: Ice for sale, Harlingen, Texas, February 1939 (detail).
Opposite: Sign, Harlingen, Texas, February 1939 (detail).
Page VI: Pie-eating contest at a 4-H Club fair, Cimarron, Kansas, August 1939 (detail).
Page VIII: Wrestling match sponsored by the American Legion, Sikeston, Missouri, May 1938 (detail).

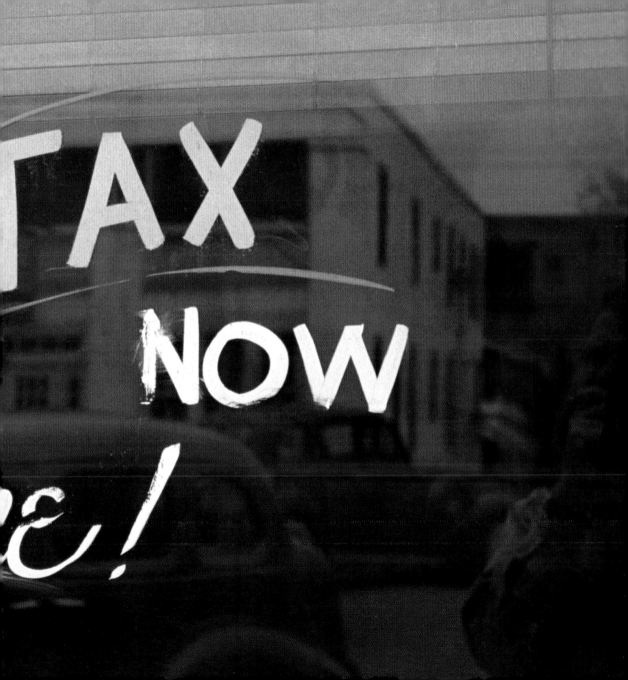

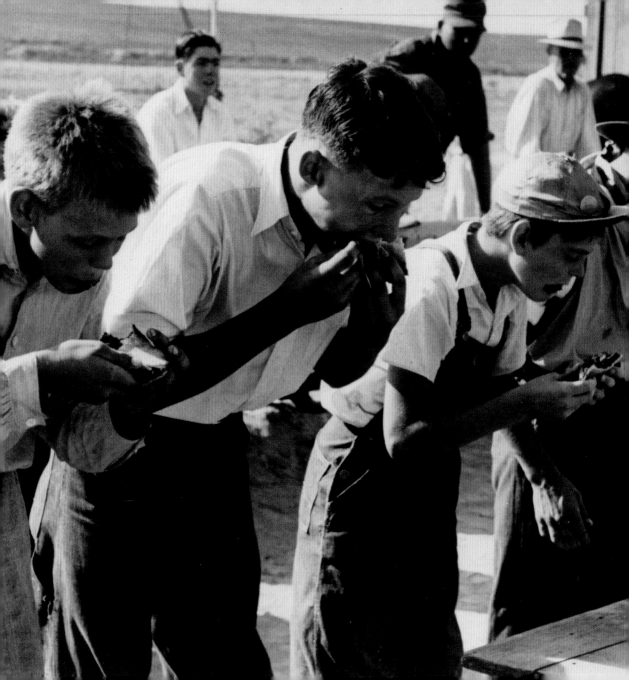

Fields of Vision

Preface

The Farm Security Administration–Office of War Information (FSA-OWI) Collection at the Library of Congress offers a detailed portrait of life in the United States from the years of the Great Depression through World War II. Documenting every region of the country, all classes of people, and focusing on the rhythms of daily life, from plowing fields to saying prayers, the approximately 171,000 black-and-white and 1,600 color images allow viewers to connect personally with the 1930s and 1940s. That's what great photographs do. They capture people and moments in time with an intimacy and grace that gently touches the imagination. Whether it is a fading snapshot or an artfully composed sepia print, a photograph can engage the mind and senses much like a lively conversation. You may study the clothes worn by the subject, examine a tangled facial expression, or ponder a landscape or building that no longer exists, except as captured by the photographer's lens long ago. Soon, even if you weren't at a barbeque in Pie Town, New Mexico, in the 1940s or picking cotton in rural Mississippi in the 1930s, you begin to sense what life there was like. You become part of the experience.

This is the goal of *Fields of Vision*. Each volume presents a portfolio of little-known images by some of America's greatest photographers—including Russell Lee, Ben Shahn, and Marion Post Wolcott—allowing readers actively to engage with the extraordinary photographic work produced for the FSA-OWI. Many of the photographers featured did not see themselves as artists, yet their pictures have a visual and emotional impact that will touch you as deeply as any great masterwork. These iconic images of Depression-era America are very much a part of the canon of twentieth-century American photography. Writer James Agee declared that documentary work should capture "the cruel radiance of what is." He believed that inside each image there resided "a personal test, the hurdle of you, the would-be narrator, trying to ascertain what you truly believe is." The writers of the texts for *Fields of Vision* contemplate the "cruel radiance" that lives in each of the images. They also delve into the reasons why the men and women who worked for the FSA-OWI were able to apply their skills so effectively, creating bodies of work that seem to gain significance with time.

The fifty images presented here are just a brief road map to the riches of the Farm Security Administration Collection. If you like what you see, you will find more to contemplate at our website, www.loc.gov. The FSA-OWI collection is a public archive. These photographs were created by government photographers for a federally funded program. Yet, they outlived the agency they served and exceeded its mission. Evoking the heartbreak of a family that lost its home in the Dust Bowl or the humiliation of segregation in the South, they transcend the ordinary—and that is true art.

W. Ralph Eubanks
Director of Publishing
Library of Congress

Russell Lee

By Nicholas Lemann

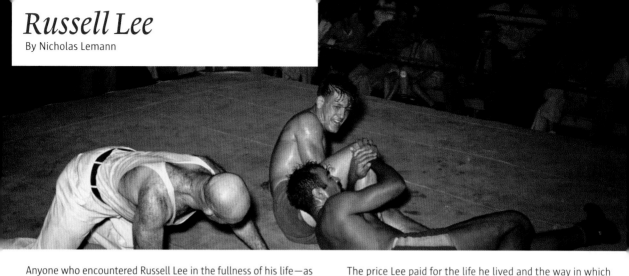

Anyone who encountered Russell Lee in the fullness of his life—as I did, in 1981—would have seen a man who looked, well...like the subject of a Russell Lee photograph. He had a broad, open, roughly handsome, weather-beaten and deeply creased face, and white hair. He wore khakis and flannel shirts and work boots and a broad-brimmed hat—the garb not of a manual laborer or a cowboy, but of someone with a white-collar job that took place outdoors in the sun, like an agricultural extension agent or an oil-company landman. He was bowlegged and a little gimpy. He and his wife, Jean, who had lived and worked together for many decades, and who constantly fussed at and about each other, owned a modest white clapboard cottage near the University of Texas campus. It was the kind of house that used to typify Austin when it was home more to employees of the state government and the university than to those of big business. Lee was deeply Texan in his appearance, if not his accent, and was old-fashioned and unpretentious. He had shot many of his photographs with a bulky box camera mounted on a tripod, using a flash, and he always insisted, even after many museum shows, that he wasn't an artist, only a craftsman. Thanks to his long residence in Austin and his years of teaching at the university, he was surrounded by people who loved him. He stood for a simpler, tougher, more distinctive, not very distant Texan past that means a lot to Texans.

The price Lee paid for the life he lived and the way in which he presented himself was to be considered a kind of folklorist, and therefore a distinct notch in importance below other photographers who had been his colleagues, like Walker Evans, Dorothea Lange, and Arthur Rothstein. John Szarkowski, the long-time curator of photography at the Museum of Modern Art in New York, in the foreword to a posthumous collection of Lee's work, patronizingly compared him to Will Rogers and Weegee. "The intuition of Russell Lee often found itself attracted to material that seemed as dumb as fence posts, as common as dirt, as flat as the prairie, out of which he made pictures that looked as artless as a good country quilt," Szarkowski wrote. Lee was the workhorse of the remarkable crew that Roy Emerson Stryker assembled to work for the Farm Security Administration during the New Deal. He made thousands of images (more than any other FSA photographer), in just about every corner of America, and he continued to work for Stryker's too lightly regarded post-FSA projects, for the Office of War Information, Standard Oil of New Jersey, the city of Pittsburgh, and Jones & Laughlin Steel, which brought him more into the realm of documenting industrial work and life, as opposed to "social conditions."

Lee produced an enormous and coherent body of work. It's hard to think of any photographer for whom a more plausible

claim can be made that he recorded the entire life of the United States (at least, for people in the bottom two-thirds of the income distribution) at a particular historical moment—what Toqueville did as a social observer, or Dos Passos as a novelist, or John Gunther as a journalist. Because nearly all of Lee's work was in the public domain and has been widely reproduced in publications and books, you probably have his images inscribed in your mind even if you don't realize it. The picture of Chicago's South Side slums in the 1930s and 40s evoked by Richard Wright in his book *Native Son* (1940), most likely derives from a photograph that Lee took, and that appeared in Wright's book *Twelve Million Black Voices* (1941). The first few establishing shots in the movie *Brokeback Mountain* (2005), featuring a small desolate Western town under an enormous, artificially bright blue sky and a background of desert—that's Lee, too, from his early color work in the 1940s. The sinuous curves of streamlined, boat-like automobiles, with angular humans (wearing sinuously curved fedoras and cowboy hats) leaning against them—that's Lee. A row of silver oil tanks looming like Stonehenge against a horizon—that too. He recorded ordinary people in the Depression who aren't poor or unemployed, and buildings that aren't abandoned: the world of the working poor, with the dignity and pride outweighing the need.

Lee's early life sounds like something out of a Booth Tarkington novel crossed with a Sherwood Anderson novel. He was born in 1903 into a prosperous family in the town of Ottawa, Illinois. His parents divorced when he was a small child. When he was ten years old, he watched an automobile strike and kill his mother as she crossed the street. After that he was raised first by his grandmother, and then, when she died three years later, his grandfather, followed by a great-uncle, and two legal guardians. In his early teens he was sent to Culver Military Academy, in Indiana, before graduating in chemical engineering from Lehigh University. If this sounds like the sort of miserable, cosseted childhood in which an artistic temperament is born, it probably was, but you'd never know it from anything Lee said or did. After college he worked in manufacturing, mainly for a company called CertainTeed that made building materials. He wound up

managing a factory in Kansas City. By this time, he had married Doris Emrick, an artist. Lee took up painting, too, and soon they made a decisive break from business and the Midwest. The Lees moved first to San Francisco and then to Greenwich Village and Woodstock, New York, which was home to an artists' colony called Byrdcliffe. Both Lees worked in a naïve, Thomas Hart Benton-like style, but Doris was by far the more talented painter of the two. Lee gave up on painting, taught himself photography, and began taking pictures of farm and townspeople in Woodstock during the early years of the Depression.

The fateful association of Lee's life was with Roy Stryker, an economist who was a student and protégé of Rexford Guy Tugwell, an essential member of the New Deal "brains trust." Tugwell brought Stryker to Washington and put him in charge of the Historical Section of the Resettlement Administration, which was soon renamed the Farm Security Administration. The Historical Section was, at least at the level of official intention, in the propaganda business: it was supposed to produce photographic images that would generate public sympathy for New Deal programs aimed at alleviating the distress of the rural poor.

But Stryker was up to something else as well. He took an obsessively detailed, taxonomic interest in American life. He sent his photographers—a crew that included Ben Shahn, Gordon Parks, and John Vachon, in addition to Evans and Lange—out into the field with highly specific written instructions, and they came back to the home office in Washington with not just negatives but also notes. If you go to the Library of Congress's website and find your way to the voluminous Farm Security file, you will discover that there is a caption for each image. Almost always, the subject is not an anonymous emblem of dignified human suffering, but someone with a name, an age, and an occupation. And there are many images that demonstrate an interest in how things work: crops in fields, factories, churches, main streets, cars, stores. The captions do not merely name, they also explain—usually how some agricultural or commercial process operates or how and when the person in the photograph got to town and what economic events are shaping his or her life. Beyond this practical, microcosmic bent, Stryker obviously

also had a superb eye for photographic talent and for memorable images, and beyond that he seems to have harbored an almost eccentrically grand ambition to create a master document of the entire life of the United States.

In 1936, Stryker hired Lee to replace one of the original crew of FSA photographers, who had left to join the staff of *Life* magazine. Lee began to spend most of his time on the road in remote rural areas, lugging a collection of cameras, flash equipment, and developing chemicals with him. He would spend weeks at a time in particular locales, usually small agricultural towns, recording every aspect of life there. His marriage ended, and in 1939, on assignment, he met a Texas newspaperwoman named Jean Smith, who became his second wife, and sometimes traveled with him on assignments. Soon, they moved permanently to Austin.

Whether because his personality and interests made such a perfect fit with Stryker's, or because he had relocated himself away from the blandishments of the big New York picture magazines, Lee became the most prolific photographer in Stryker's stable. He was constantly on assignment, all over the country but especially in the Southwest. When Stryker's interests broadened, as is generally agreed by scholars of the FSA project, from agriculture to cities, Lee shot in New York and Chicago. When, after the outbreak of World War II, Stryker's photographers were redeployed to military photography, Lee took assignments in the realm of military aviation. And when, in the early 1940s, Stryker tired of the shortening of his leash that being a generator of propaganda for a nation at war entailed, and left the federal government to start an ambitious new photographic project at Standard Oil of New Jersey (now ExxonMobil), Lee, despite the fierce disapproval of his wife, went with him.

It is difficult to bring to mind today both how far to the Left the FSA photographers were, and how deeply they despised Standard Oil. For a staunch friend to the poor and advocate of the expansion of the federal government like Stryker to lend his talents to a public-relations effort by America's most powerful corporation was, to say the least, counterintuitive. Stryker's motivation seems to have been, if not artistic, at least editorial:

he was attracted by the opportunity to expand and continue his great recording project, with a generous budget and considerable freedom, and that chance no longer existed in Washington.

It is true that the Standard Oil assignments generally had to do with the oil industry: there are many images of oil tanks, oil rigs, oil refineries, and Standard Oil company towns like Tomball, Texas, and Linden, New Jersey. But, as at the FSA, Stryker interpreted his charter broadly. Even the narrowly industry-related assignments were so typically (for Stryker) taxonomic that they stand as documents not just of the oil business, but of all aspects of small-town life—domestic, religious, recreational—in the 1940s. Many of these images are even more evocatively strange to the contemporary eye than are the FSA images. Agricultural poverty is still with us today, all over the world (though in the United States, it is no longer represented by pictures of white people). America depicted as a hearty, materially modest, heavy-industrial country, a place where many people still wore homemade clothing and where regional cultures were more distinctive than the national popular and consumer culture, seems utterly exotic.

After the Standard Oil project, Stryker moved to Pittsburgh to do similar work, on a much smaller scale, first for a local civic group and then for the Jones & Laughlin Steel Company. Lee undertook some assignments for him there, too. As Stryker's active assigning and editing career wound down and he turned his attention to creating archival homes for the images he had made, Lee did some magazine work, but by the late 1950s his career was winding down too. For a short-lived "little magazine" published by the University of Texas he went to Italy and, uncharacteristically, produced some images purely for their elegance and beauty. That work would not look out of place in a show of landscapes at a photography gallery today.

In the 1960s and 70s, Lee worked mainly as a teacher. During the third quarter of the twentieth century, he was an essential and beloved figure in a now forgotten Texas liberal world—the world evoked in William Brammer's novel *The Gay Place* (1961). His friends were the editors and writers at the *Texas Observer* (for which he went on assignment during the 1950s), liberal

politicians like Ralph Yarborough, the Democratic senator whose campaigns Lee photographed, intellectual rebels on the University of Texas faculty such as William Arrowsmith, writers including J. Frank Dobie, the locally famous folklorist, and his many students and protégés. He spent much time fishing in Texas's manmade lakes and leading expeditions to his favorite barbecue restaurant, Louis Mueller's in Taylor, Texas. He died, to all appearances a deeply and justifiably contented man, in 1987.

Aesthetically, Lee has sometimes been criticized for being completely artless, in the manner of an insurance-claims adjuster who has to send back pictures with his report, and for using a bulky box camera on a tripod with a flash, which necessarily produced work that feels motionless and staged. The images in this book ought to show how unfair these accusations are. First, Lee was in fact an early user of light 35-millimeter cameras and brought them on most assignments, along with his heavier equipment. He could and did capture the moment and brought a sense of the fluidity of motion to his pictures. Much of his most memorable work, though, was middle-range landscape—those modest, foursquare Western buildings shot from low down, with a limitless emptiness looming behind them. Those images, which sometimes include human figures, not for portraiture, but to convey the scale and purpose of the building, are intended to be static. The rectangular border of the frame is a strong design element: the image is as firmly bounded as the lonely towns Lee photographed, where after the last building there was absolutely nothing. Other pictures are sociological still lifes, using commercial typography and the textures of building materials to convey the essence of a particular place and time. They, too, are meant to convey stillness.

The subjects of Lee's portraits do often look straight, and self-consciously, at the camera. They are not posed, exactly, if that means asking someone to act for the sake of a photograph. They have a strong sense of composition and of human feeling. His subjects seem to be one or two notches up the sociological scale from the direly poor and more anonymous subjects of Lange's and Evans's most famous FSA images. They are almost never prosperous, but they are often dressed in what

would have to have been their best clothes—a dress, a suit and tie—and they therefore obviously have jobs (if it weren't obvious, we would know anyway from the caption). Even agricultural workers picking crops in fields, set like points on a graph against the rows where a plow has been, possess a certain order and dignity. Lee took on an unusually heavy load of assignments in ethnic-minority communities—Harlem, the South Side of Chicago, the Lower Rio Grande Valley, the Nisei internment camps of World War II—and he seems to have been particularly interested in showing the aspirational, middle-class side of these places. (If all you had to go on were Lee's photographs, you'd conclude that in the 1930s and 40s, black people were better off than white people.) Although he was an economic liberal and a champion of plain people, he was not as ideological as many writers and artists of his generation (such as, to use a near-at-hand example, his wife Jean). Lee was simply not comfortable as a photographer showing his subjects as victims or as people who had been defeated by larger malign social forces. They always seem to have hope, and in some images they are almost cheesily happy. Lee's most famous assignment, carried out in the dreary, remote hamlet of Pie Town, New Mexico, in 1940, is, in its level of detail, practically a dissertation on anthropology, and its overall mood may not be idyllic, but it is nowhere near desperation.

Journalistically, Lee was a real New Dealer—an economic determinist. The only photographs in this book that don't show people in their economic context are those in which the subject is religious life. Otherwise, there is always a signifier of the commercial matrix in which people exist. The young couple on page 22 lie together on the lawn of a county fair, a practical-minded Eden where recreation would surely have mixed with business, and they look far more purposeful than besotted. The man sitting at the counter of a small-town café on page 5 has his back to us, but we can tell roughly what kind of work he does from the tools in his back pocket, and what his lunch is going to cost him from the menu on the wall, and how much sympathy he's going to get from the waitress through the distracted look on her face and the direct line from her gaze to

the cash register. The three men on page 27 are stick figures, dominated first by a pickup truck, then by a gas station, its pumps and its structure rendered in supersaturated primary colors, and then by the endless sky. The purpose of society seems to be to carve something out of the Western emptiness, and the purpose of individual people seems to be to wear work clothes, to drive work vehicles, to produce.

Psychologically, everyone in Lee's photographs seems a little lonely. His people aren't so much unconnected, as connected only via constant struggle. The landscape is too big for them, the imperatives of working and buying and selling too powerful, the time too short. Aesthetically, Lee plays with the conventions of a small-town studio photographer, but then he takes them off kilter. He makes portraits, and records local landmarks and events, but angles and lights them unusually. The picture on page 42 presages Robert Frank's photographic book *The Americans* (1958): it's a small-town barbecue, but people are wandering out of the frame, and nobody's looking at the camera or at each other, and the background is cluttered with cars. They're saying grace, and everything about the composition and color palette of the image conveys both the nobility and the impossibility of this attempt to form a deep community tie outside the bounds of life's ceaseless economic struggle.

Russell Lee and Roy Stryker made for an extraordinary pairing of talents and sensibilities. Both men were children of the small-town middle of the country, both were interested (being, as they were, an economist and an engineer) in how things worked, both were closet or accidental aesthetes (especially Stryker), and both had an unquenchable curiosity about the life of the country and an affection for ordinary people going about their routines.

Although the FSA project and its successors were important in the story of photography's ascent to the status of a major art form, and in that sense seem like harbingers of the present, in most ways the FSA images appear old-fashioned. Many photographers today whose work is considered significant are journalists, but the work of Lee and the other FSA photographers is journalistic in a different way. It is specific, non-mythologizing,

plain, un-beautiful. There was a direct connecting line between the FSA and *Life* and *Look* magazines, but those magazines are gone and so are big government and corporate photography projects. Many photographers today are political, but Lee and Stryker were not political in the same way. They were populists, not moralists, and their political aims were not so much to awaken the nation's conscience as to get particular pieces of legislation passed. (Lee deserves a measure of credit for the creation of the first mine-safety laws, because of the power of his work on coal miners in the 1940s.) Many photographers today are artists. Lee, though trained as a painter, always claimed not to be an artist. He had a point: his work is not just totally devoid of self-conscious gorgeousness or portent, it also attempts not to present the viewer with any sense of the creator's consciousness at all, because the attention is so strongly on the subjects of the photographs. John Szarkowski proposed a categorical scheme in which photographers used the camera either as a mirror into themselves or as a window out onto the world. Lee's camera was pure window.

In these ways, Lee's work subverts some of our notions about what makes for great photography. It was accomplished within a patronage system that was a million miles from the galleries, museums, and glossy magazines that support serious photography today. Instead, it was hard, quotidian work, sponsored by large bureaucracies in government and business; it was made generally available to anyone who wanted to publish it, without individual credit; its overt purpose was public relations. On assignment, Lee and the other photographers were under orders to comport themselves as mundane, detailed data-collectors. Photographs were merely a more efficient means of making a record of this particular material than words or statistics would have been.

With sympathy and precision, Lee made a world from thousands of images that is distinctively his—a territory where people look and behave in a certain way and where a set of home truths about life pertains. His world has a depth and richness of human feeling that the work of many photographers who occupy higher places in the pantheon never comes close

to achieving. If Lee was, in fact, by that measure, an artist, was he consciously so? Did he simply prefer not to own up to the extent of his ambitions? Or is artistic genius simply not a useful concept in this case, as long as a creative person of Lee's dedication and talent keeps doggedly to his work?

1

Secondhand tires displayed for sale, San Marcos, Texas, March 1940.

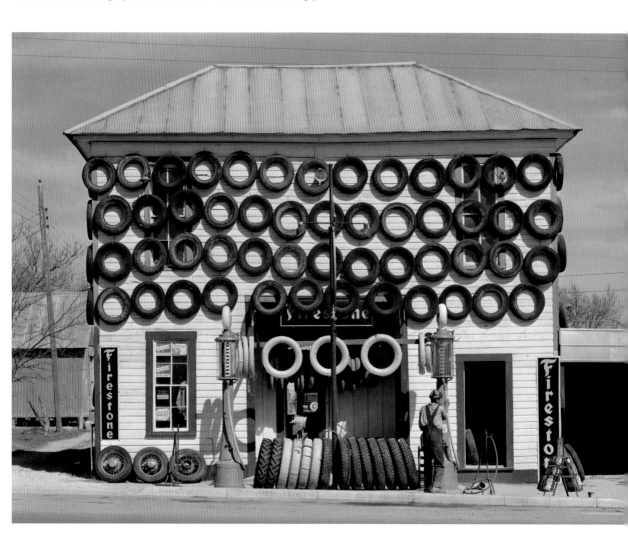

Hauling crates of peaches from the orchard to the shipping shed, Delta County, Colorado, September 1940.

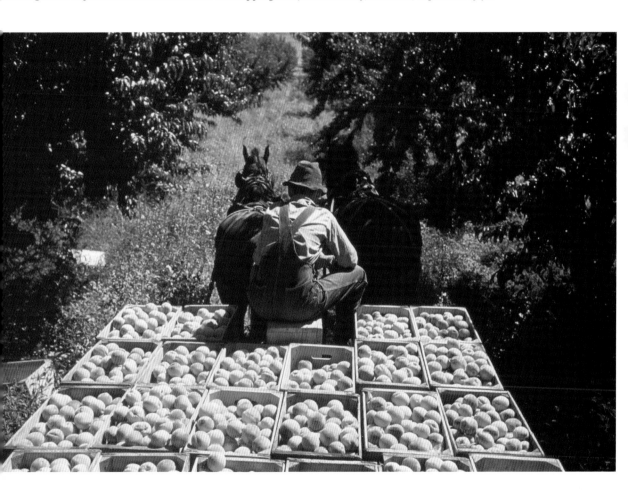

3

Wrestling match sponsored by the American Legion, Sikeston, Missouri, May 1938.

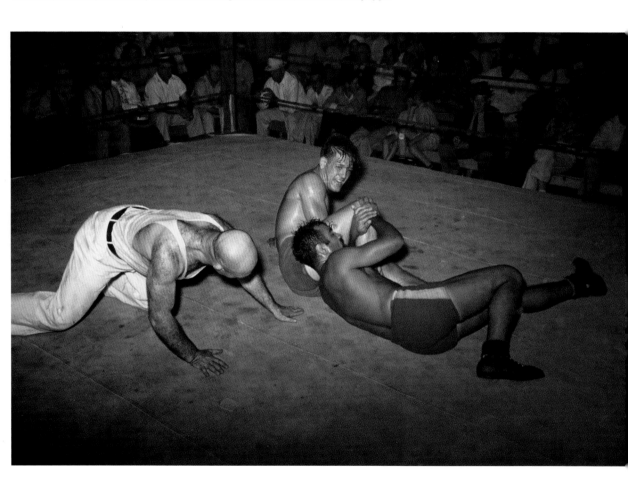

Throwing a calf near Marfa, Texas, May 1939.

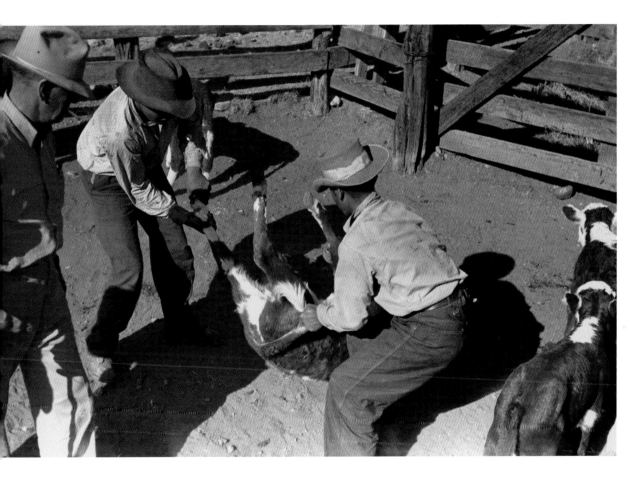

5

Man in a hamburger stand, Alpine, Texas, May 1939.

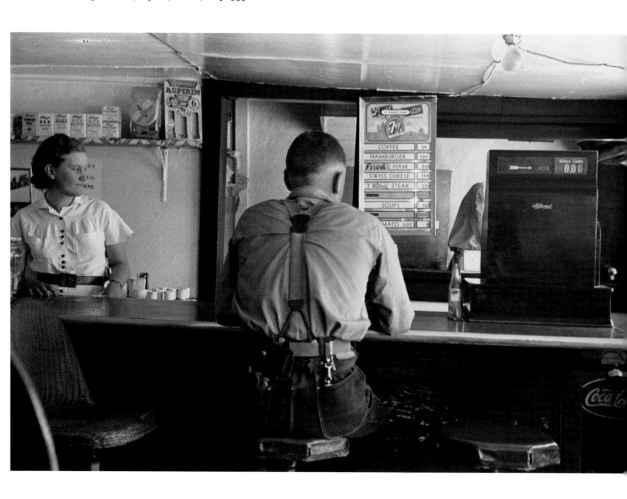

Chicken vendor at a farmers' market, Weatherford, Texas, May 1939.

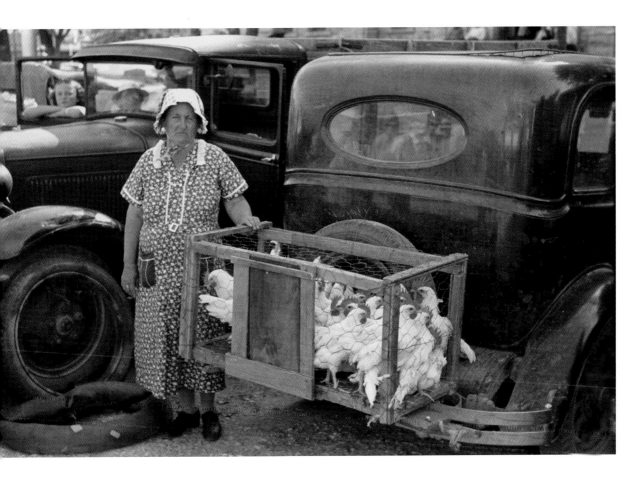

Ice for sale, Harlingen, Texas, February 1939.

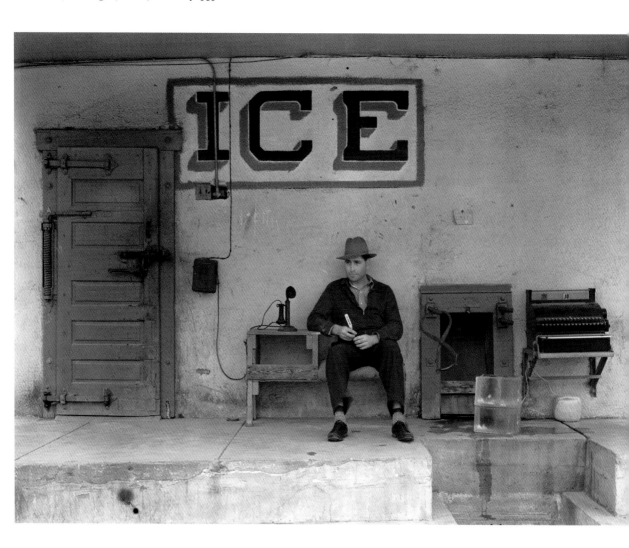

Pool hall, Shasta County, California, November 1940.

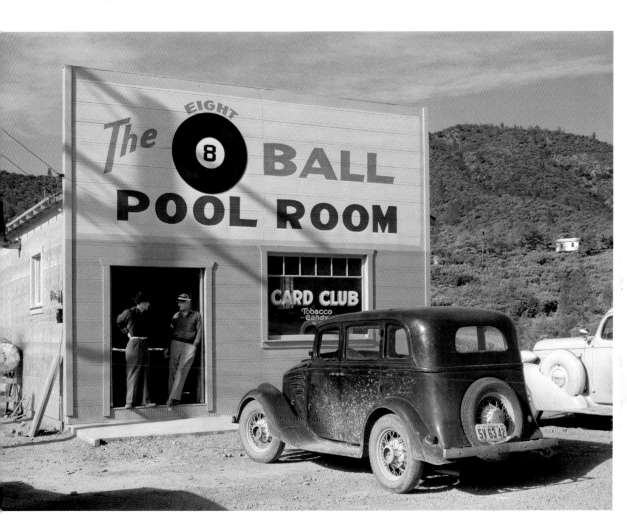

9

Members of the Moors, a religious group, Chicago, Illinois, April 1941.

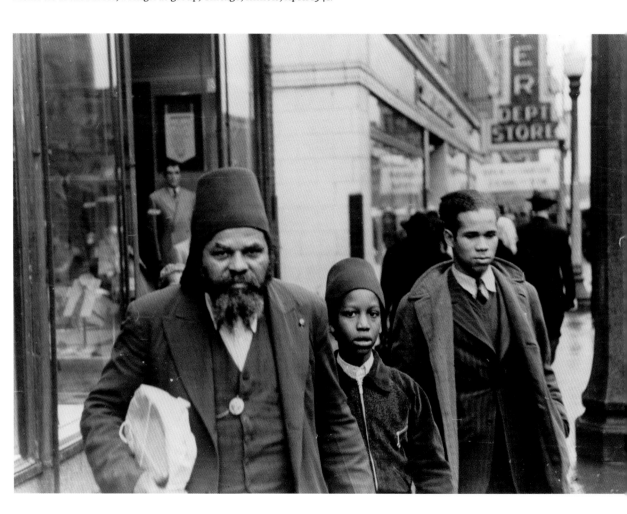

Abandoned building, South Side of Chicago, Illinois, April 1941.

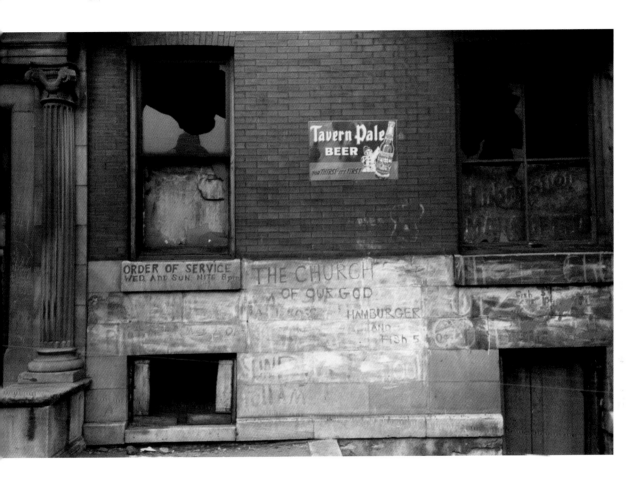

Mailboxes in Catron County, New Mexico, April 1940.

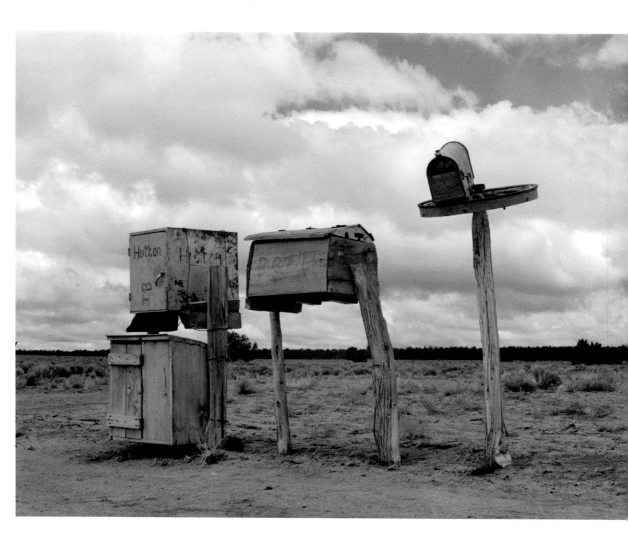

General Merchandise store on Main Street in Pie Town, New Mexico, October 1940.

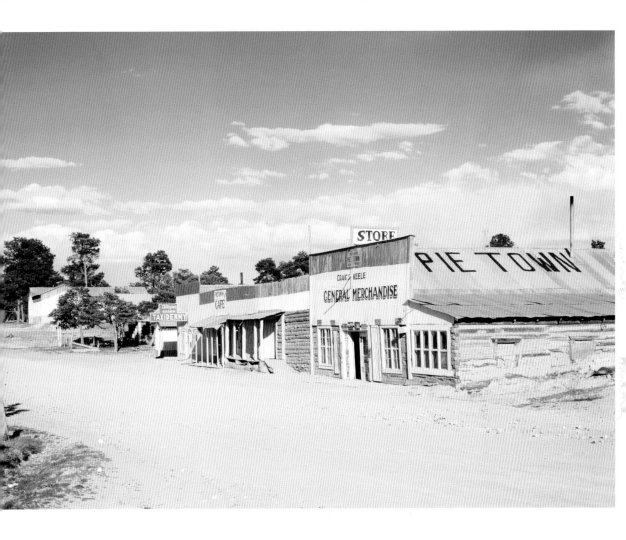

Mexican barber, San Antonio, Texas, March 1939.

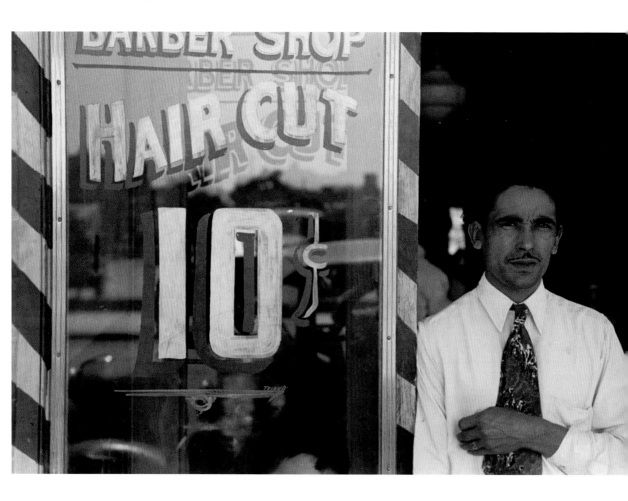

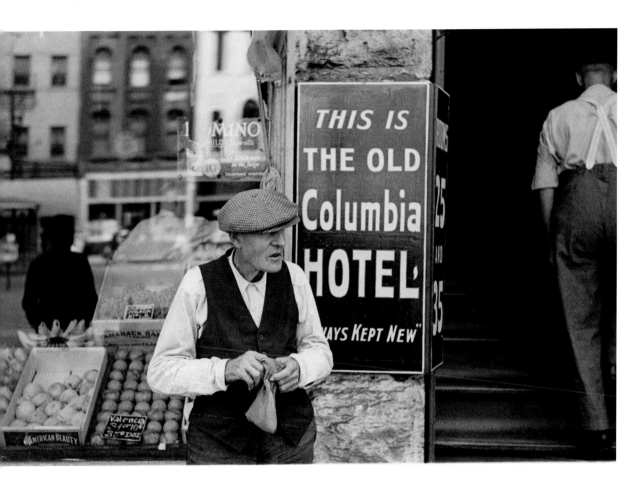

14

Columbia Hotel, Gateway District, Minneapolis, Minnesota, August 1937.

Little girls playing, Lafayette, Louisiana, October 1938.

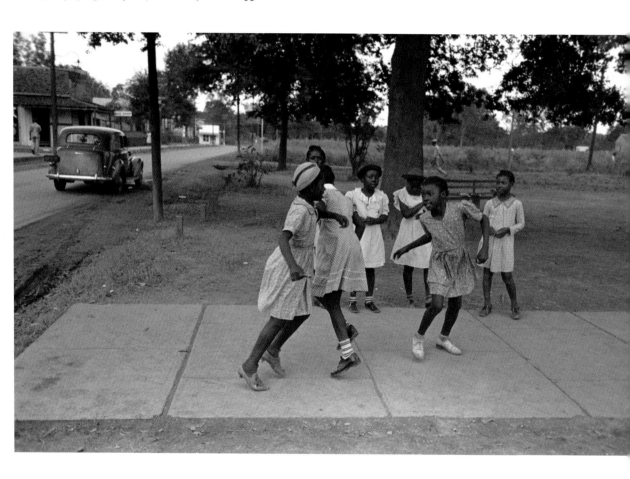

Little girls with their dolls and buggies, Caldwell, Idaho, June/July 1941.

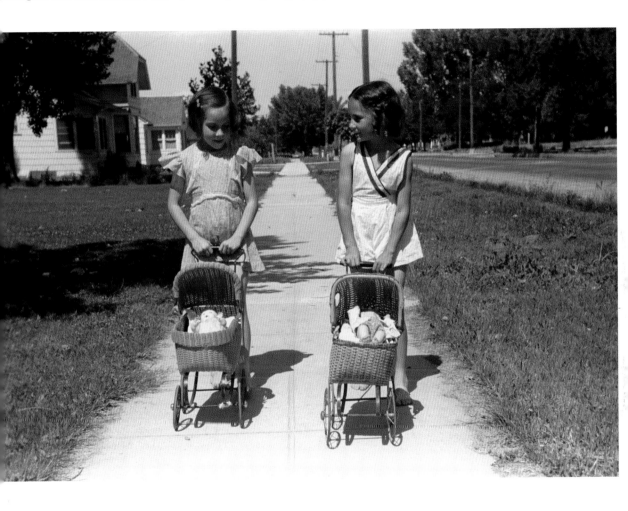

Catholic Church, Llano de San Juan, New Mexico, July or October 1940.

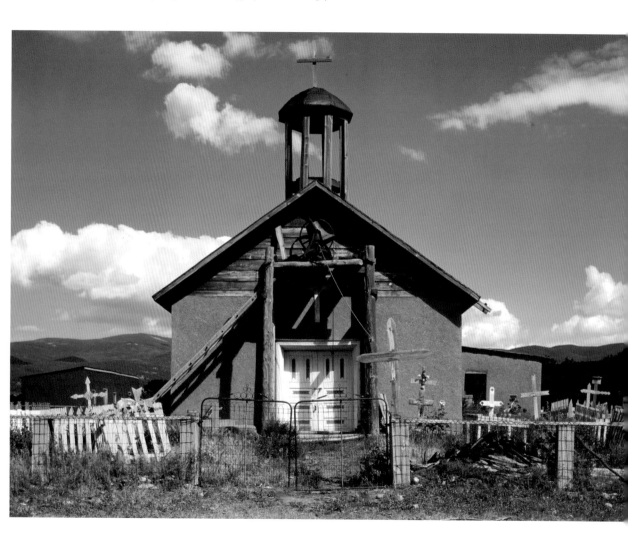

Part of the processional of an Episcopal Church, South Side of Chicago, Illinois, April 1941.

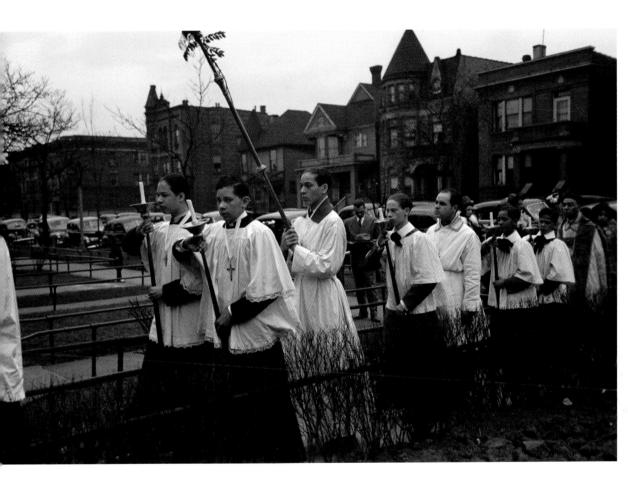

19

Easter morning, South Side of Chicago, Illinois, April 1941.

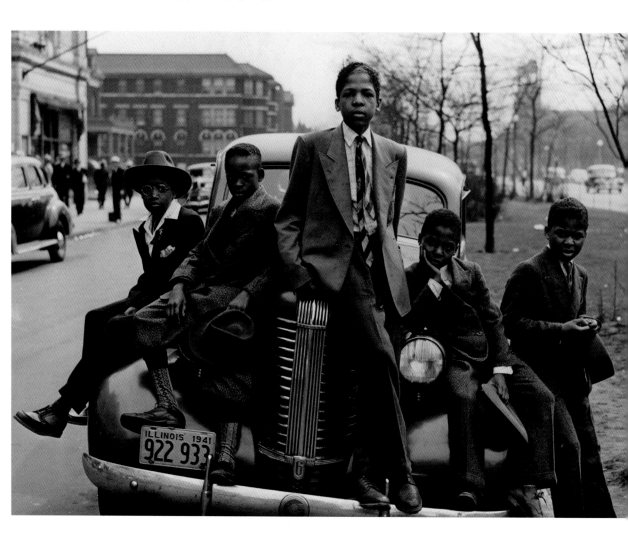

Migrant child sitting in the backseat of the family car, east of Fort Gibson, Muskogee County, Oklahoma, June 1939.

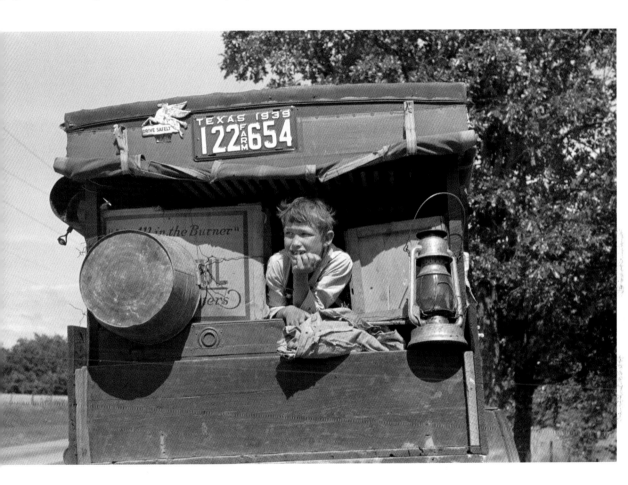

Couples at a square dance, McIntosh County, Oklahoma, 1939 or 1940.

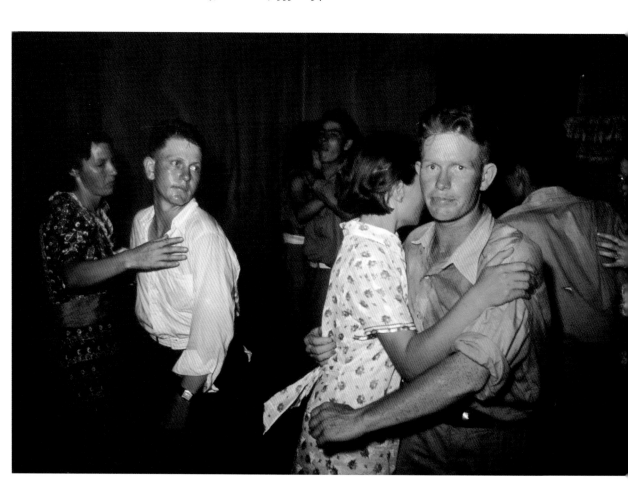

Young people at the Imperial County Fair, California, February/March 1942.

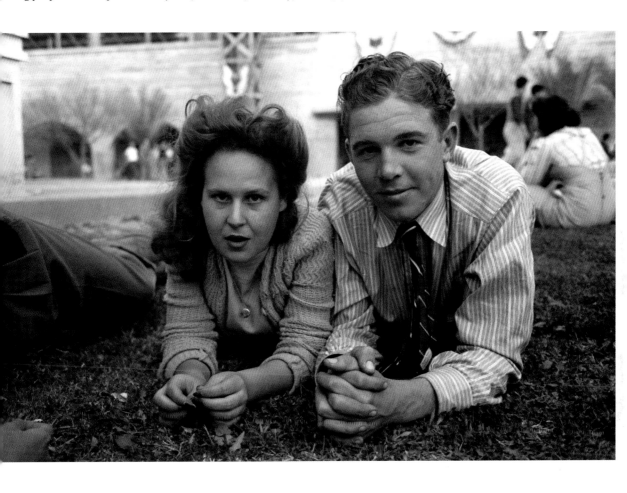

Street vendor's goods, Waco, Texas, November 1939.

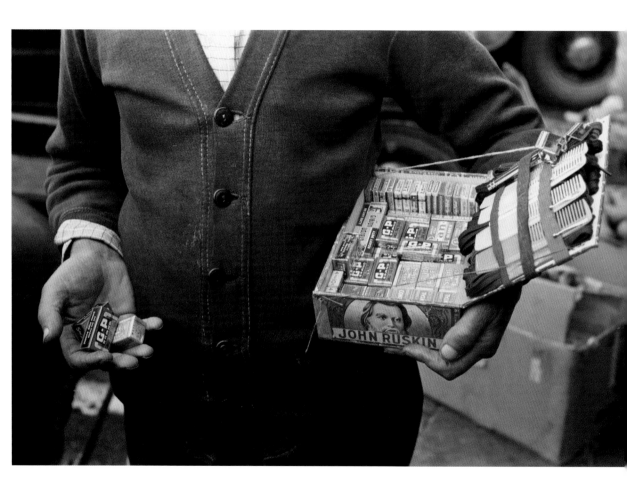

Boys and girls, Caldwell, Idaho, June/July 1941.

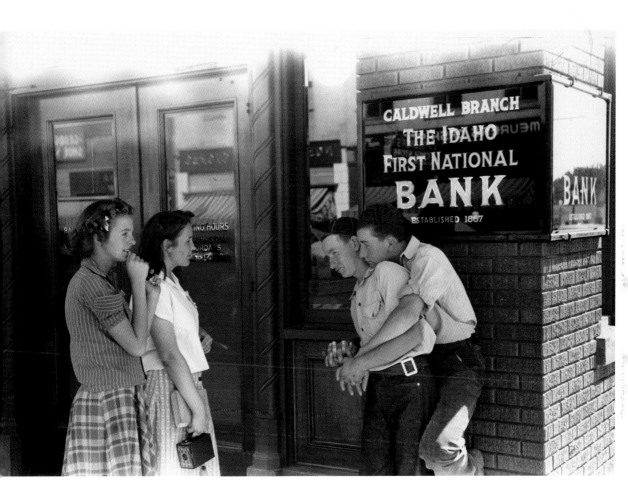

Sign, Harlingen, Texas, February 1939 (photographer's reflection visible at right).

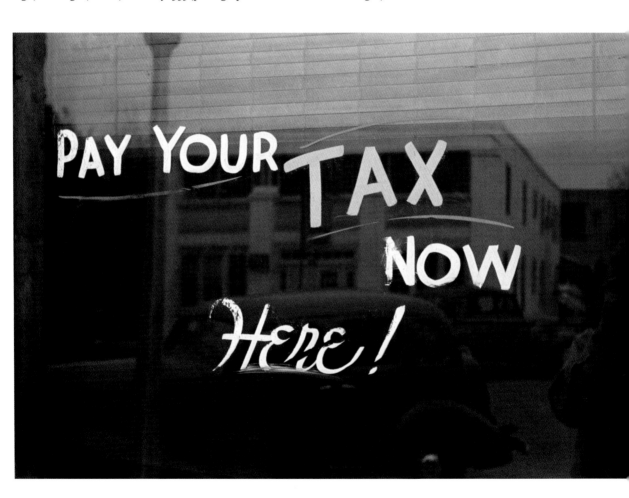

Magazine stand, Yreka, California, July 1942.

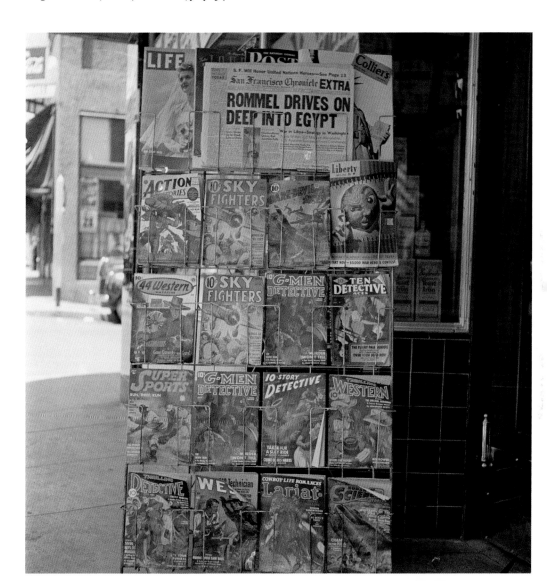

Filling station and garage at Pie Town, New Mexico, October 1940.

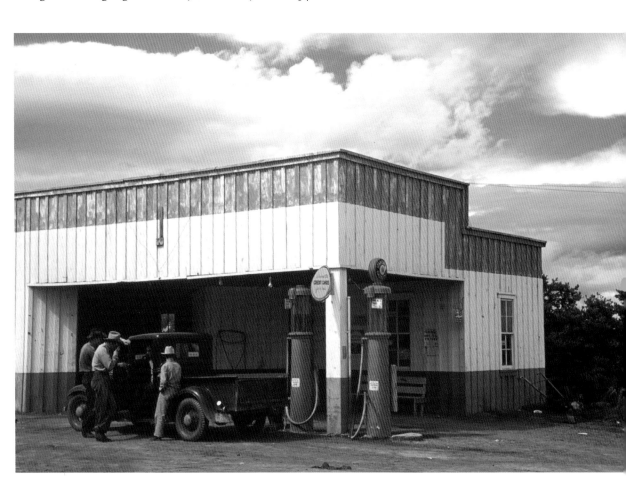

Hay stack and peach pickers' automobiles, Delta County, Colorado, 1940.

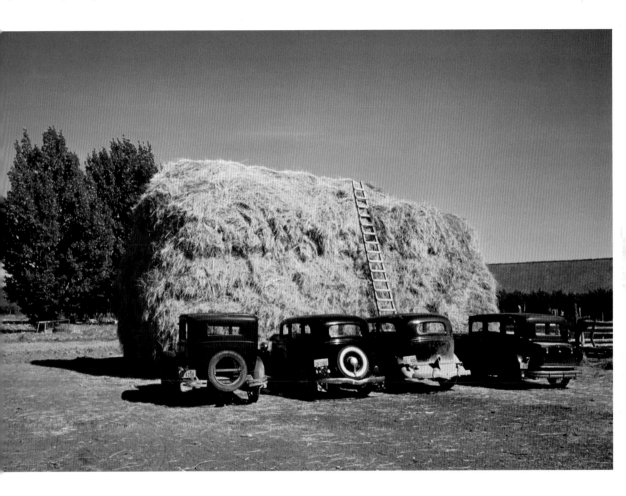

Japanese-American camp, Tule Lake Relocation Center, Newell, California, 1942 or 1943.

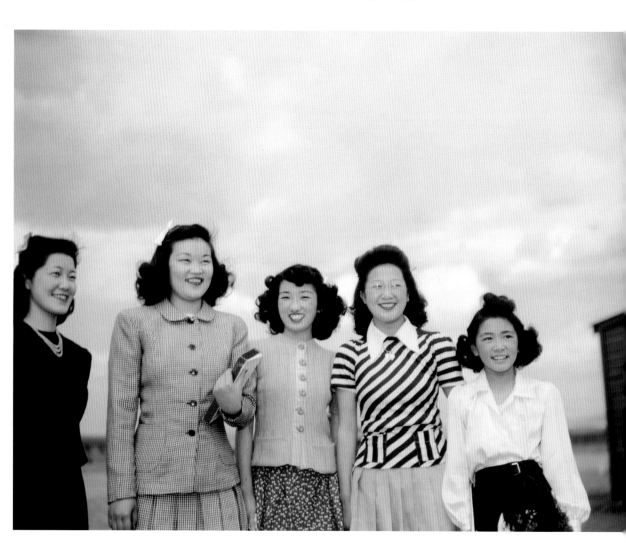

Farm Security Administration client with his three sons, Caruthersville, Missouri, August 1938.

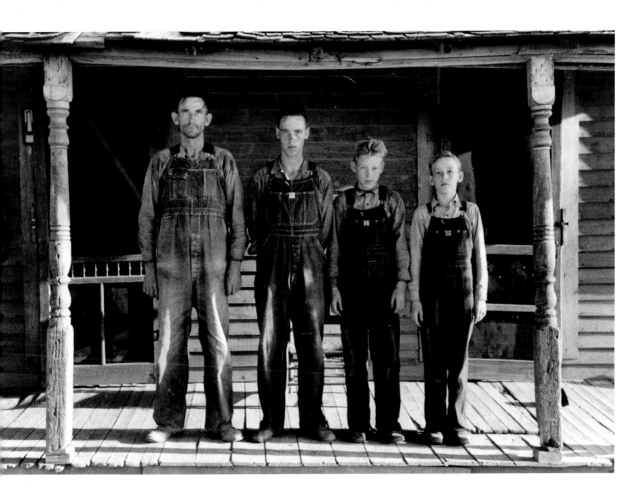

In front of the movie theater, Chicago, Illinois, April 1941.

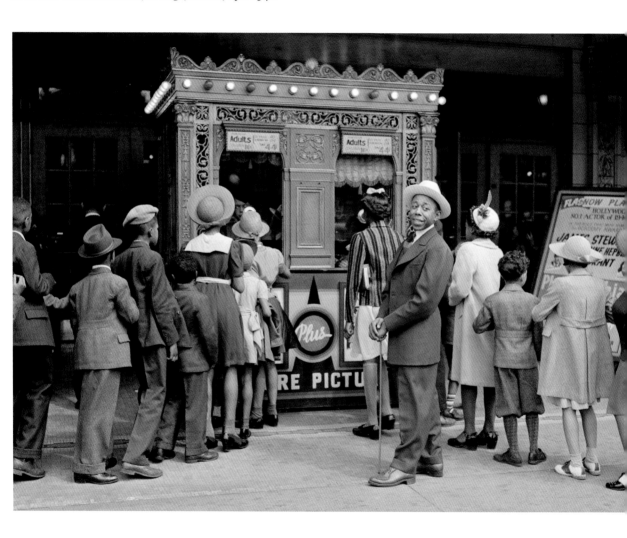

Musicians playing the accordion and a washboard in front of a store near New Iberia, Louisiana, November 1938.

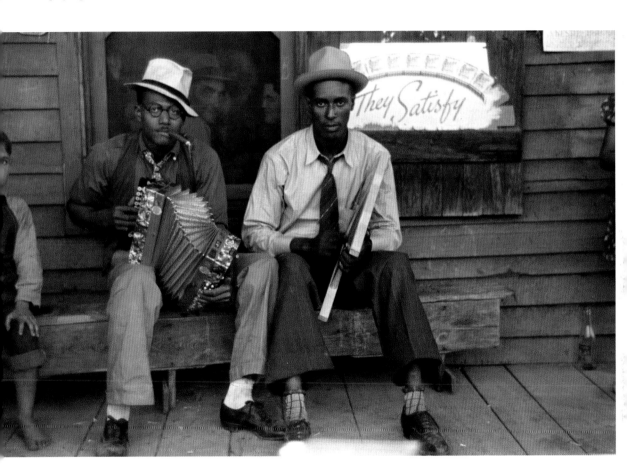

Homesteader Mrs. Jim Norris with homegrown cabbage, Pie Town, New Mexico, October 1940.

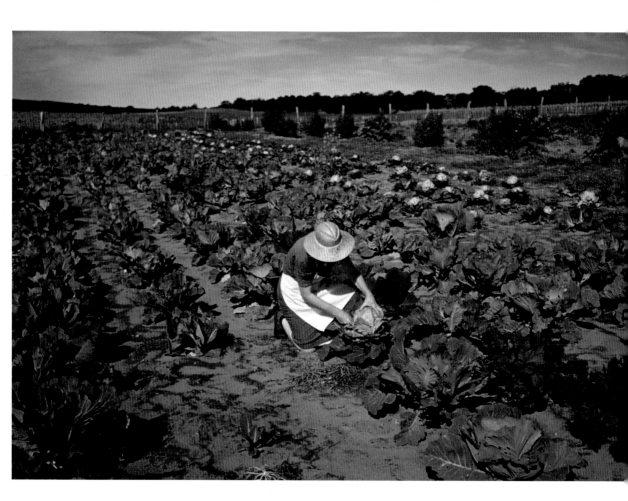

Chopping cotton, Southeast Missouri Farms, New Madrid County, Missouri, May 1938.

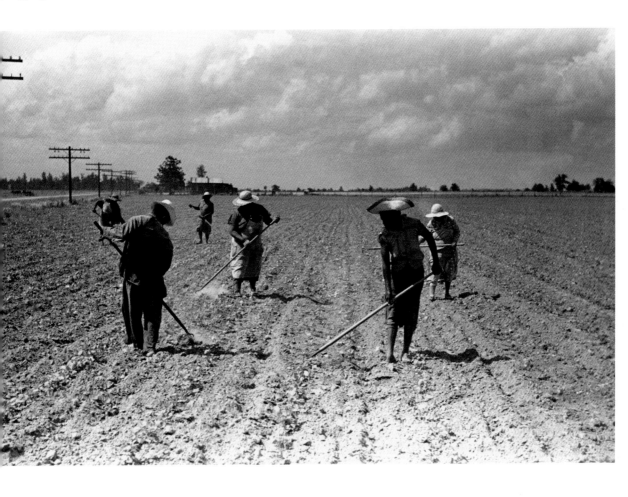

Mr. and Mrs. Marcus Miller and their dog, Spencer, Iowa, December 1936.

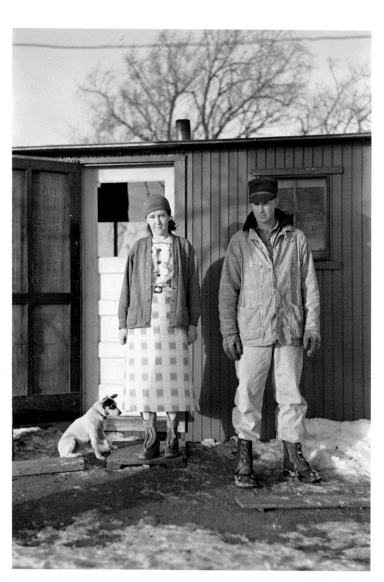

36

Female rodeo performer, San Angelo Fat Stock Show, San Angelo, Texas, March 1940.

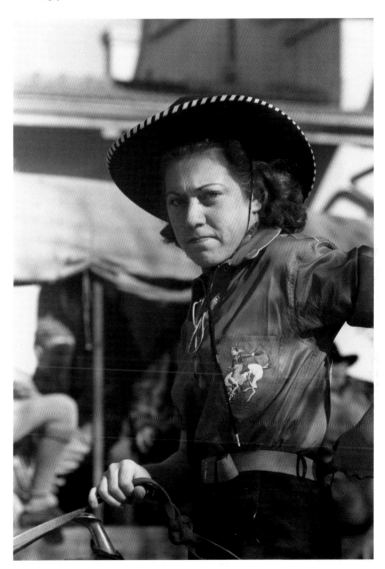

Pie-eating contest at a 4-H Club fair, Cimarron, Kansas, August 1939.

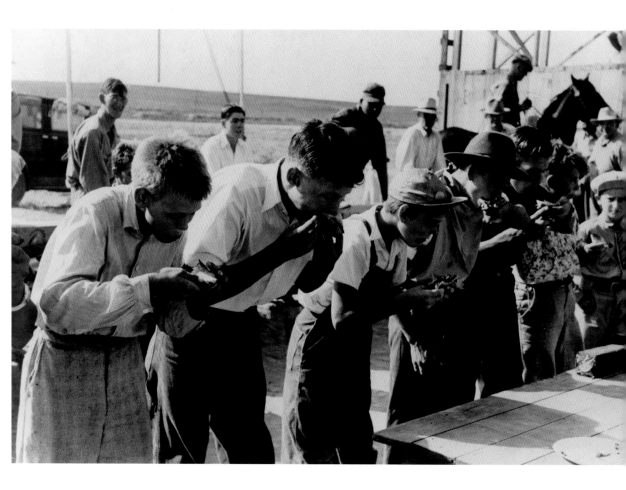

Boys sitting on a street-side bench, Waco, Texas, November 1939.

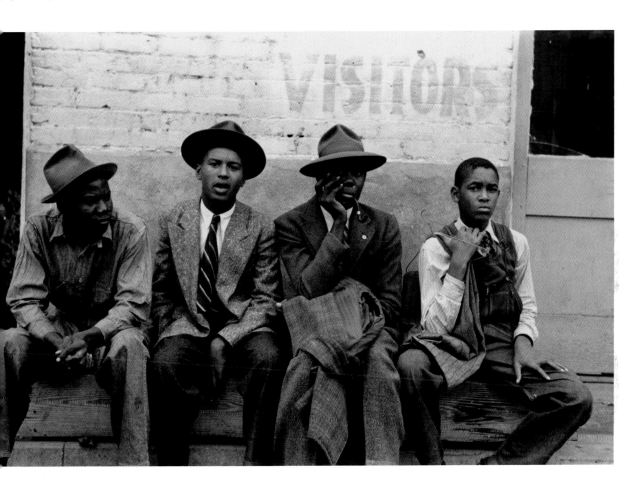

Homesteaders Faro and Doris Caudill, Pie Town, New Mexico, October 1940.

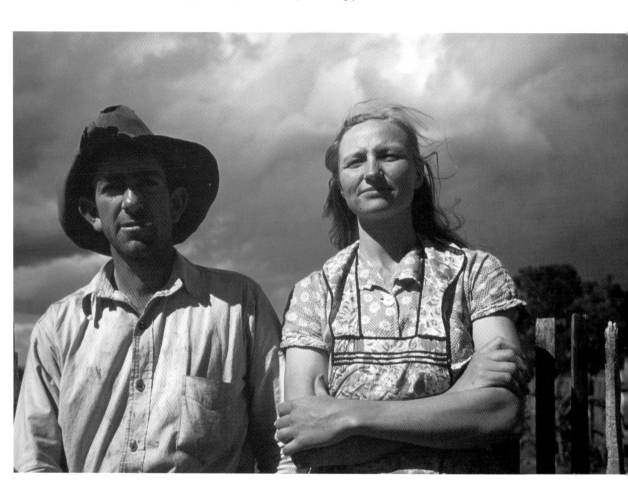

Interlude after watching the Fourth of July parade, Vale, Oregon, July 1941.

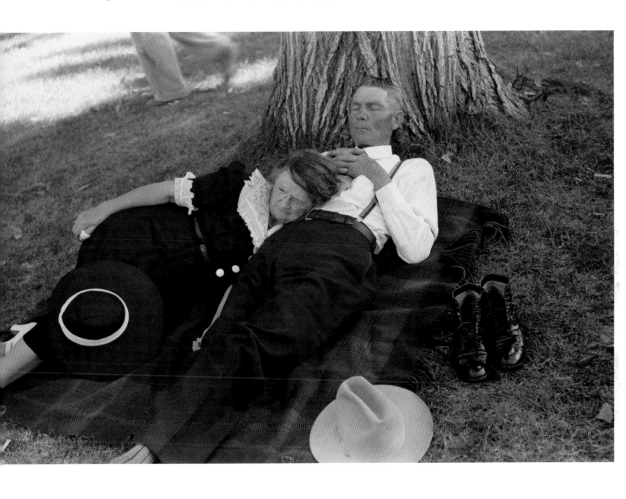

A man crossing himself and praying over the grave of a relative in a cemetery, All Saints' Day, New Roads, Louisiana, November 1938.

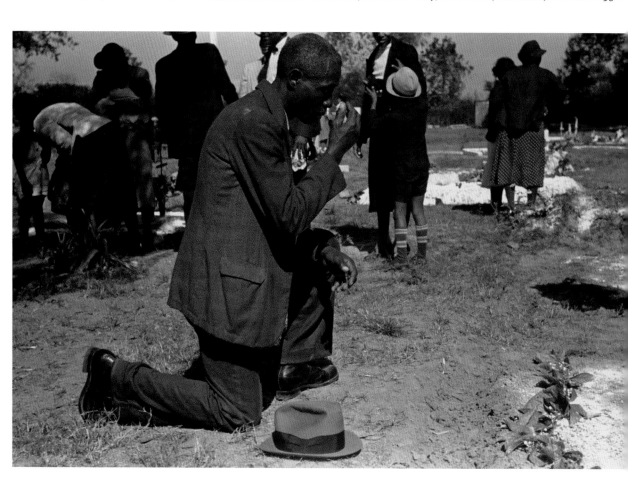

Saying grace before a barbeque dinner at the Pie Town fair, New Mexico, October 1940.

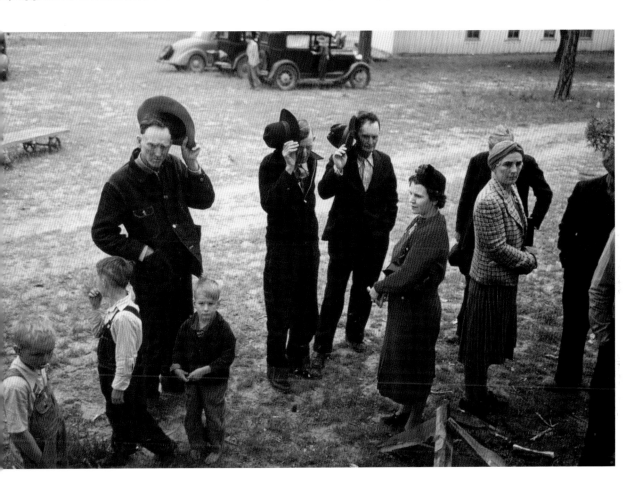

Boys in front of an A&P market waiting for jobs to cart home groceries, Chicago, Illinois, April 1941.

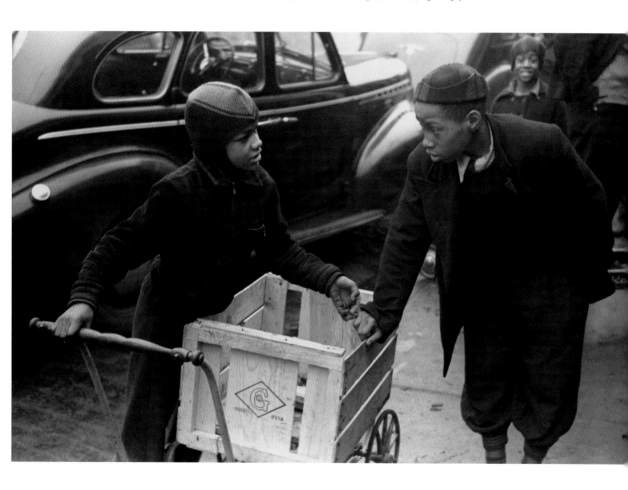

Farmer's child sitting in an automobile waiting for her father to come out of the general store, Jarreau, Louisiana, November 1938.

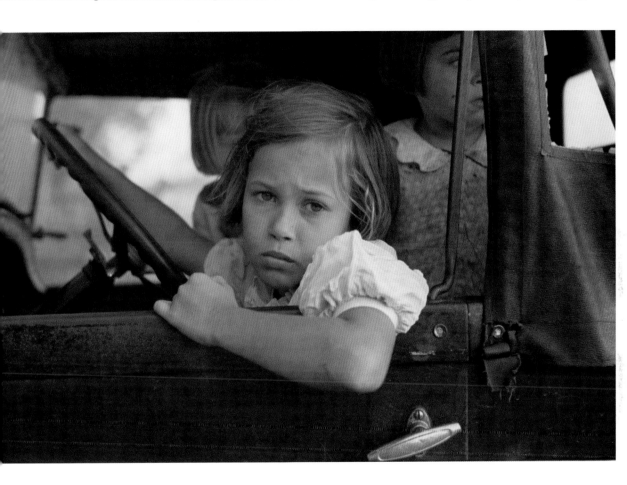

Labor Day celebration, Silverton, Colorado, September 1940.

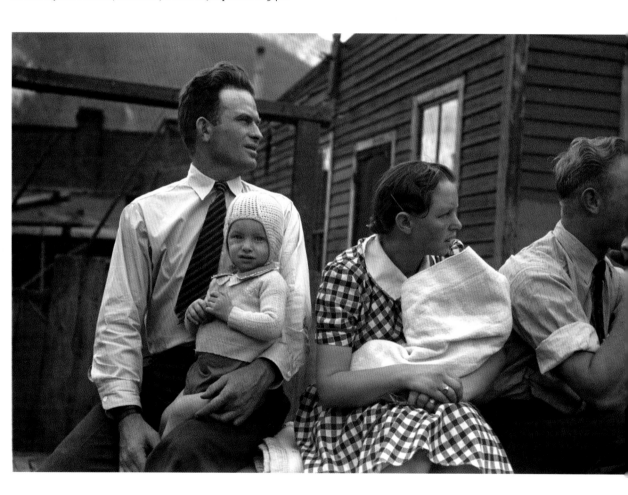

Japanese-American child being evacuated with his parents, Los Angeles, California, April 1942.

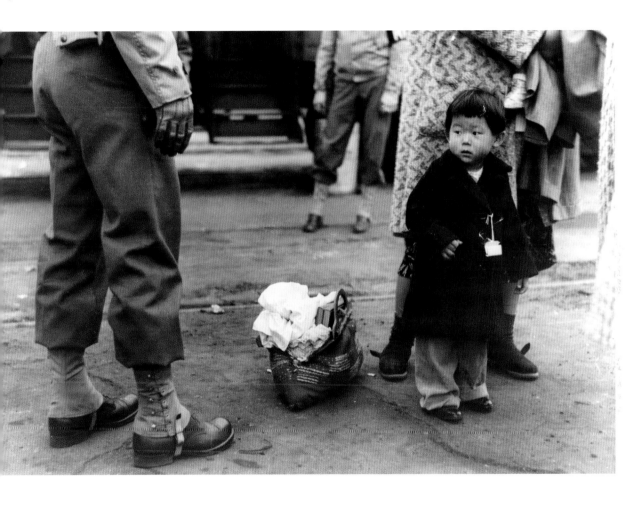

Abandoned garage on Highway Number 2, Western North Dakota, October 1937.

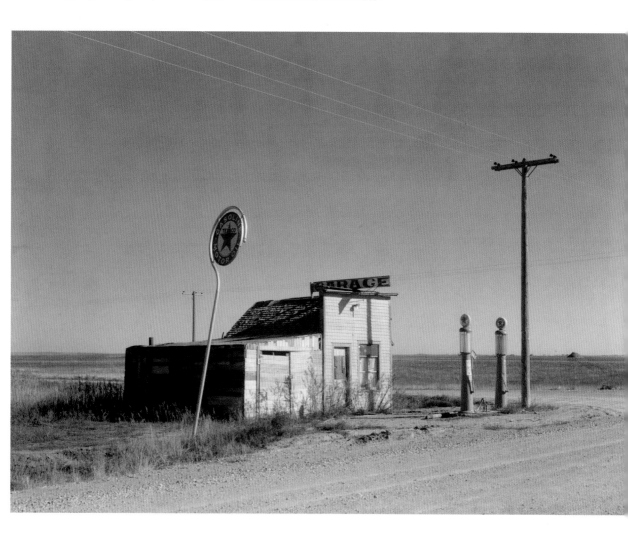

Front porch of a sharecropper cabin, New Madrid County, Missouri, May 1938.

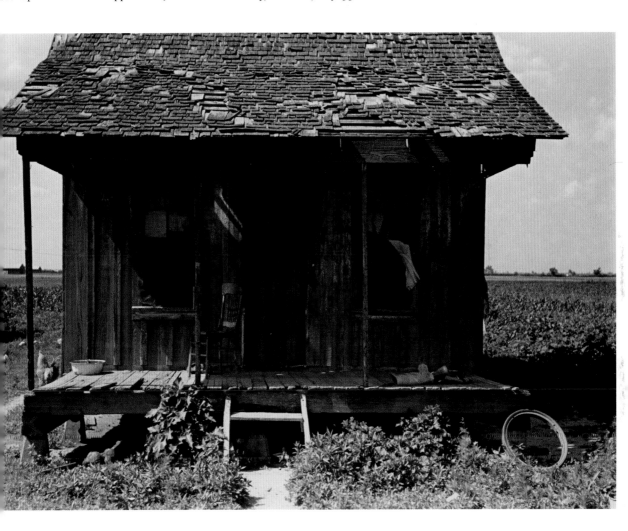

Loading logs onto trucks, Malheur National Forest, Grant County, Oregon, July 1942.

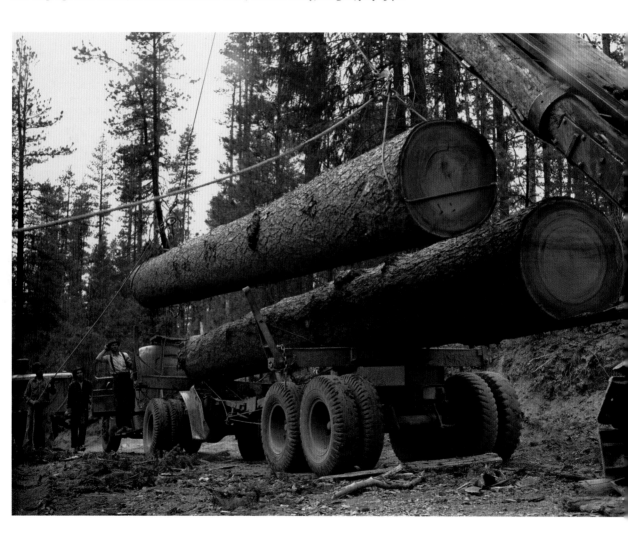

Day laborer, Lake Dick Project, Arkansas, September 1938.

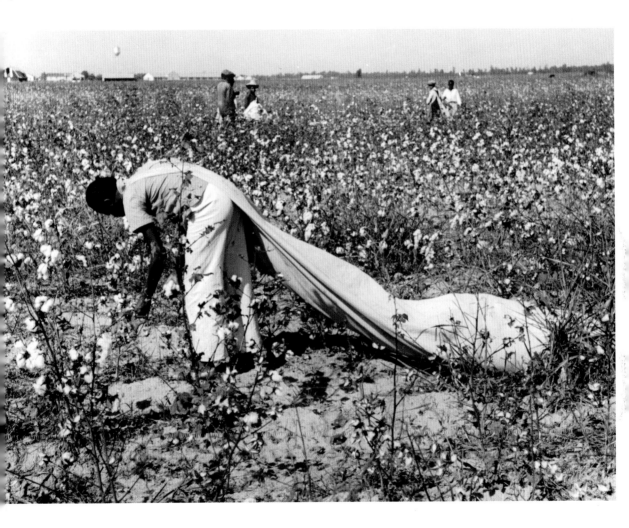

Images

The images in the Farm Security Administration–Office of War Information (FSA-OWI) Photograph Collection form an extensive pictorial record of American life between 1935 and 1944. In total, the collection consists of about 171,000 black-and-white film negatives and transparencies, 1,610 color transparencies, and around 107,000 black-and-white photographic prints, most of which were made from the negatives and transparencies.

All images are from the Library of Congress, Prints and Photographs Division. The reproduction numbers noted below correspond to the page on which the image appears. Each number bears the prefix LC-DIG-fsa (e.g., LC-DIG-fsa-8a16183). The entire number should be cited when ordering reproductions. To order, direct your request to: The Library of Congress, Photoduplication Service, Washington, DC 20450-4570, tel. 202-707-5640. Alternatively, digitized image files may be downloaded from the Prints and Photographs website at http://www.loc.gov/rr/print/catalog.html.

1. 8b24220
2. 1a34196
3. 8a23143
4. 8a26578
5. 8a26203
6. 8a26538
7. 8b37254
8. 8c00200
9. 8a29964
10. 8a29935
11. 8b24483
12. 1a34163
13. 8a25635
14. 8a28732
15. 8a24660
16. 8a30215
17. 1a34155
18. 8a29976
19. 8c00916
20. 8a26531
21. 1a34090
22. 8a31137
23. 8a27487
24. 8a30220
25. 8a25171
26. 8c32317
27. 1a34107
28. 1a34202
29. 1a35015
30. 3c29087
31. 8c00905
32. 8a24838
33. 1a34099
34. 8a23253
35. 8a21403
36. 8a28081
37. 3c30594
38. 8a27485
39. 1a34096
40. 8a30301
41. 8a24771
42. 1a34140
43. 8a29880
44. 8a24798
45. 8a29584
46. 8a31196
47. 8b20071
48. 8a22953
49. 8c32416
50. 3c30063